Mandalas for Meditation

SCRATCH-OFF NIGHTSCAPES

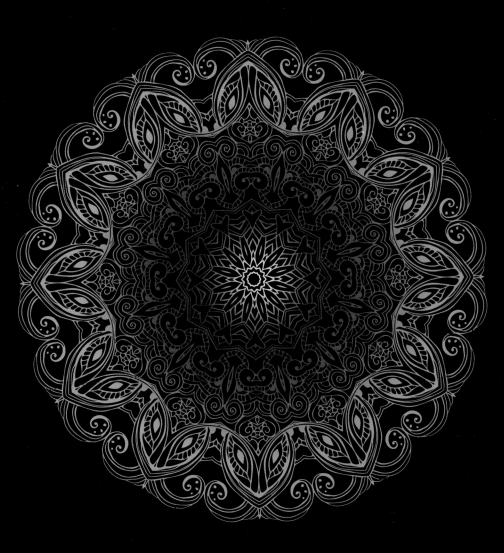

LARK
New York

ABOUT THIS BOOK

MANDALAS ARE ANCIENT, archetypal symbols of wholeness that appear in nature (in everything from atoms to flowers to eyes to stars) as well as in human culture and religion since prehistoric times. Take the meditative calm of coloring a step further when you bring the dramatic, stunning mandalas in this book to light.

How to Create Your Art

1. Take out the stylus enclosed in the cardboard at the back of the book.

2. Tear out the scratch-off page you would like to work on and place it on a flat work surface such as a desk or table.

3. Using the stylus, apply light pressure to trace over the gray lines, scratching them off to reveal the brilliant colors underneath.

4. Display the stunning final pieces of art or give them as gifts to friends or family.

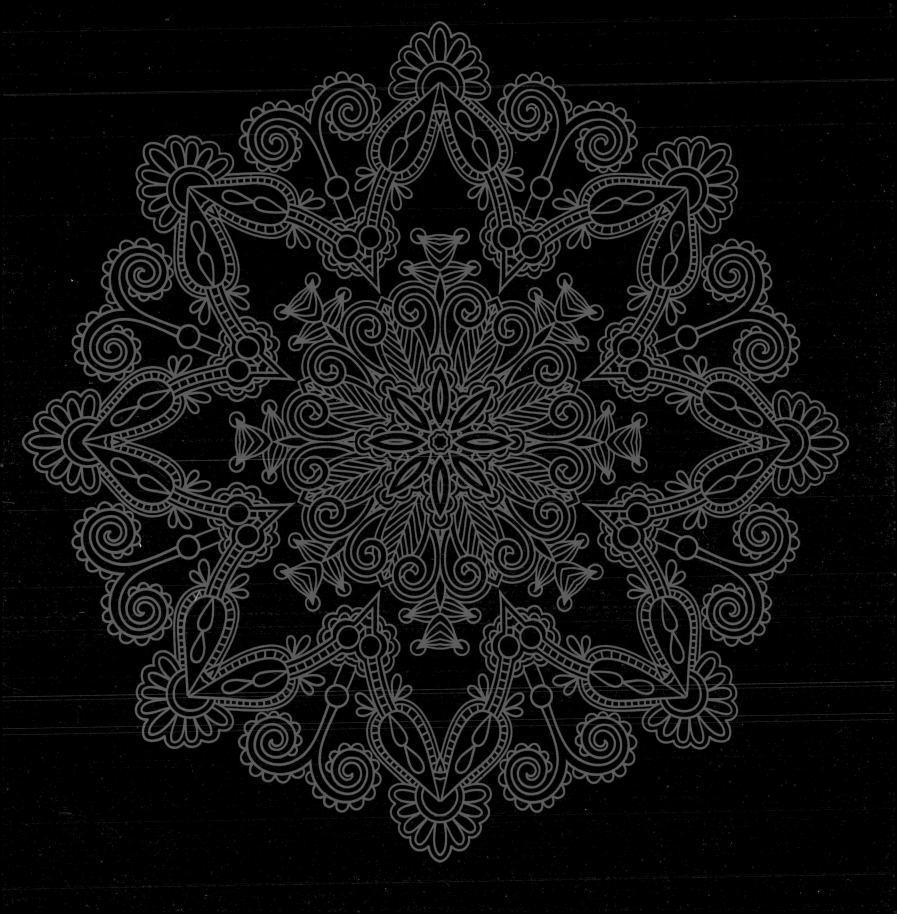

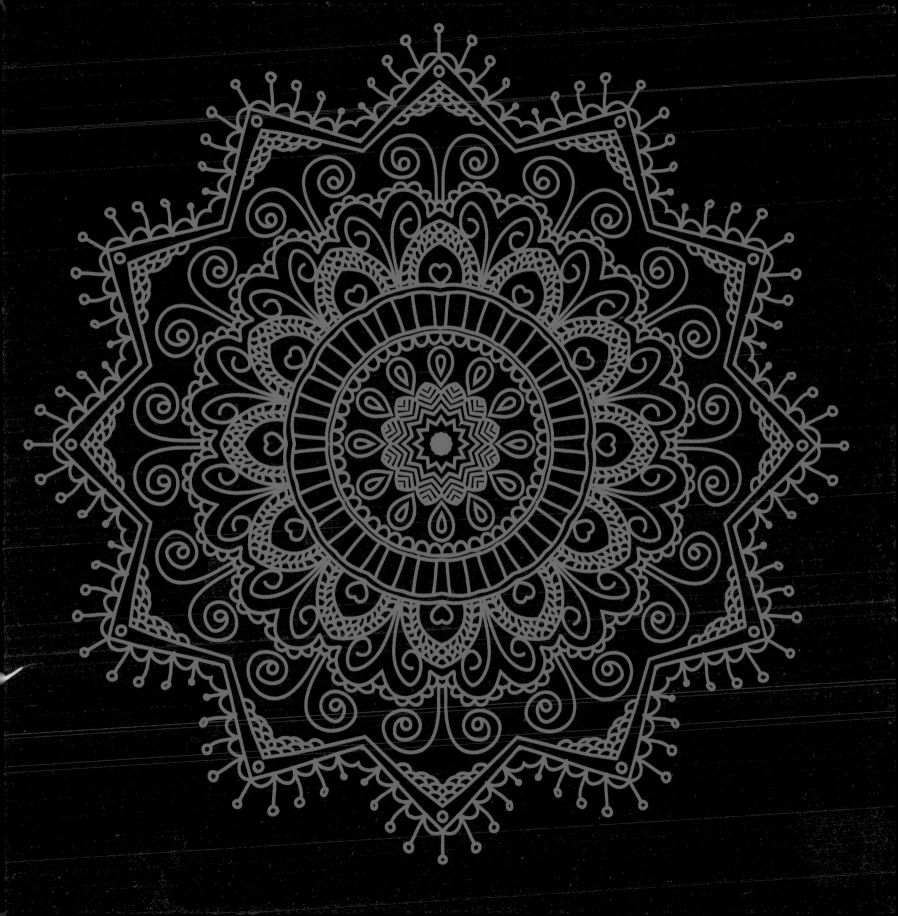

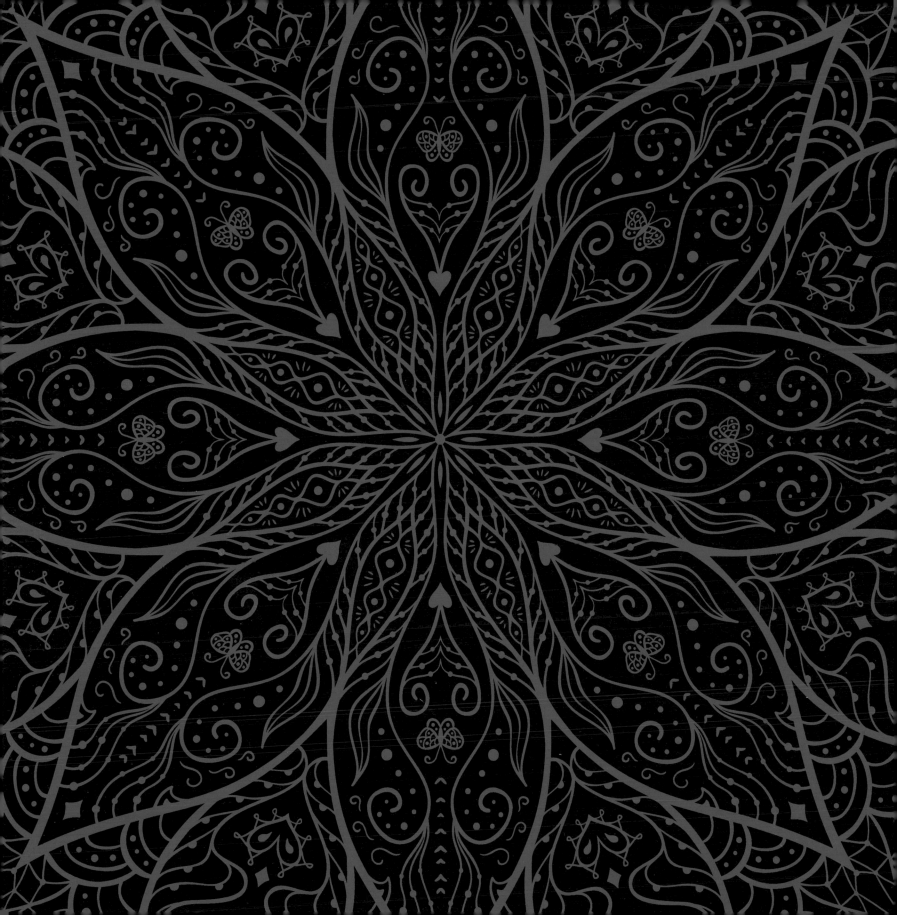

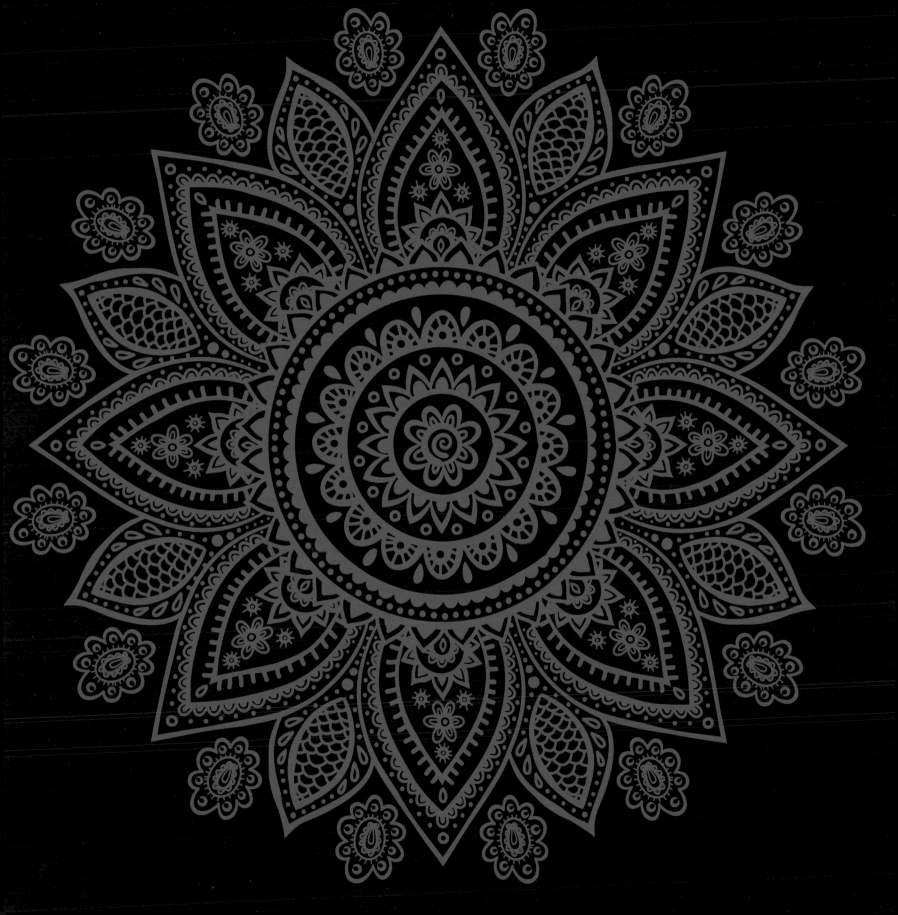

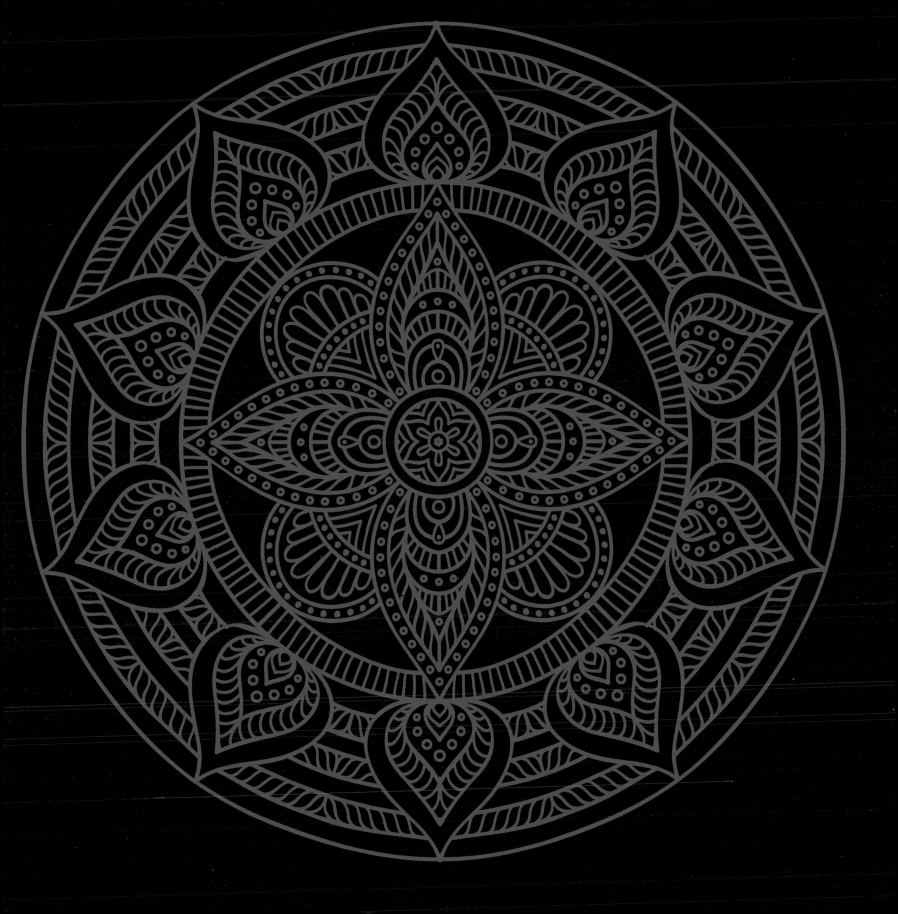

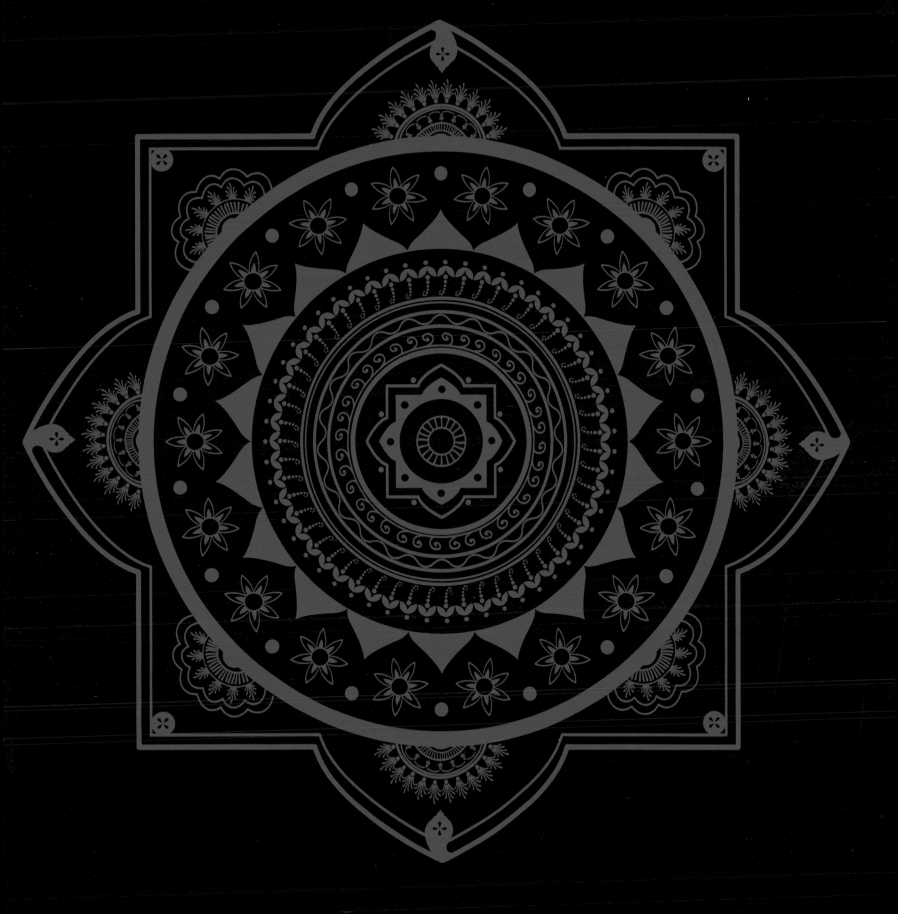

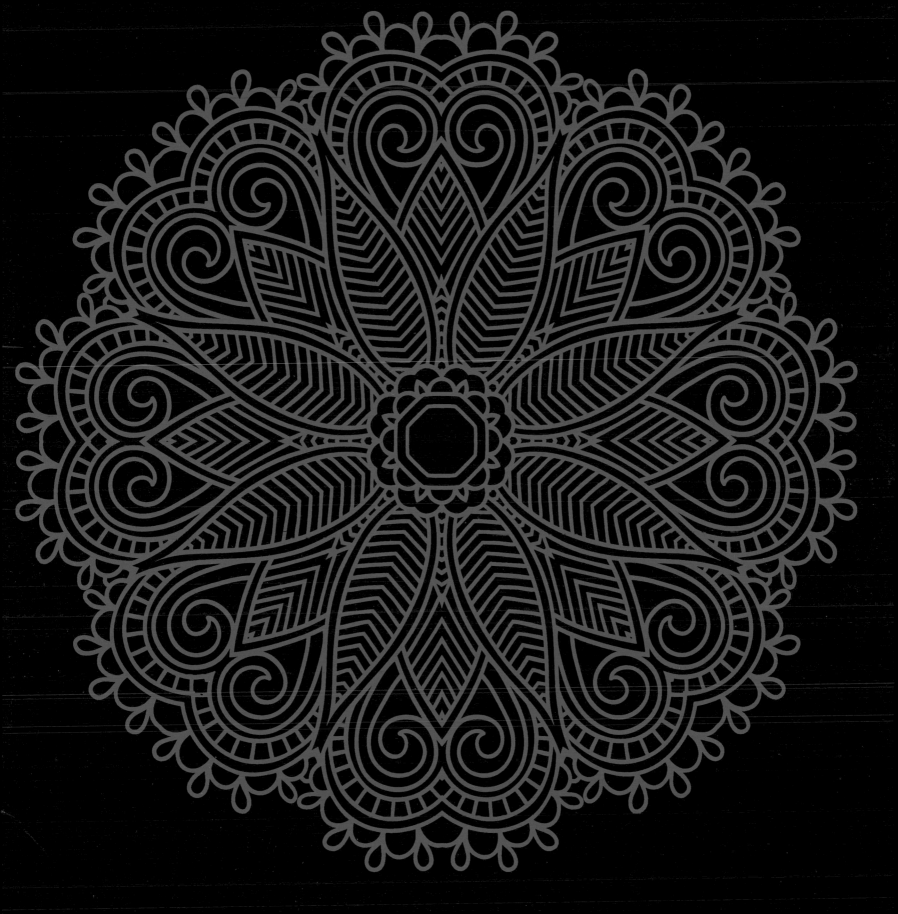

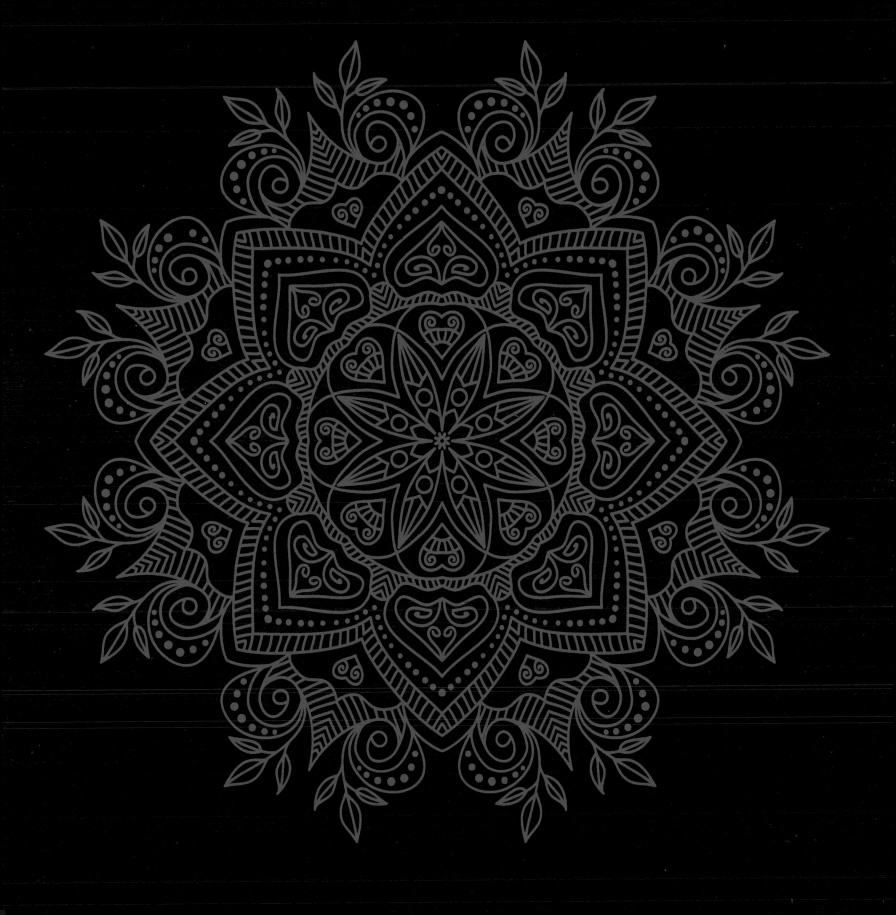

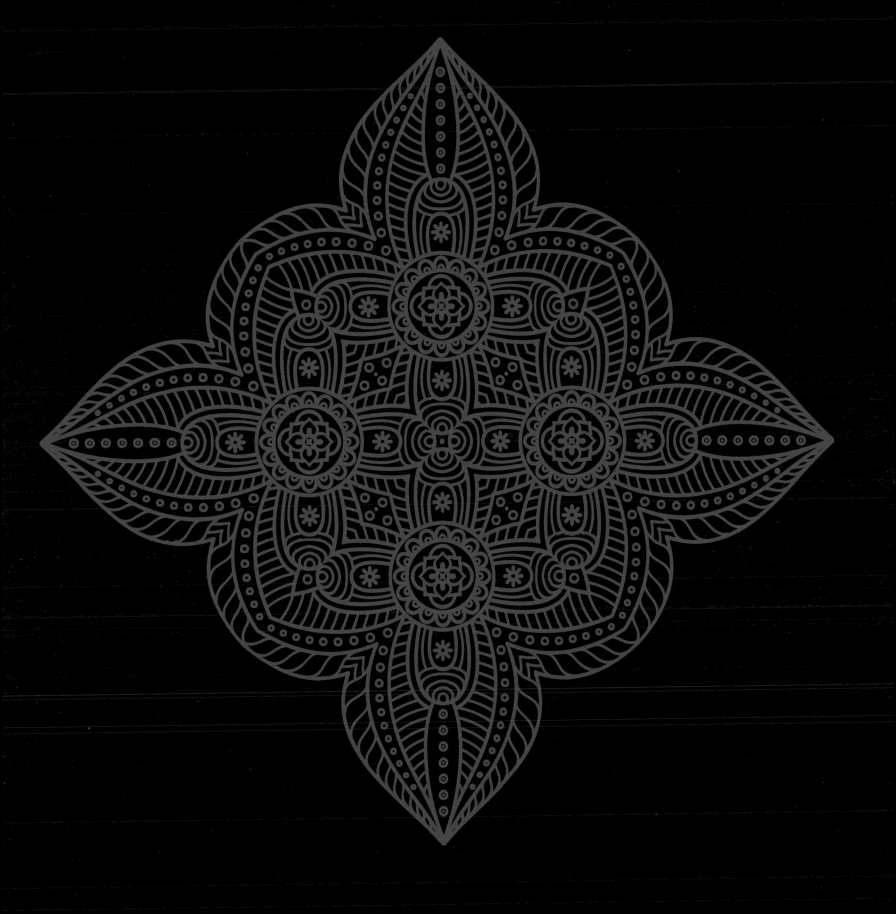

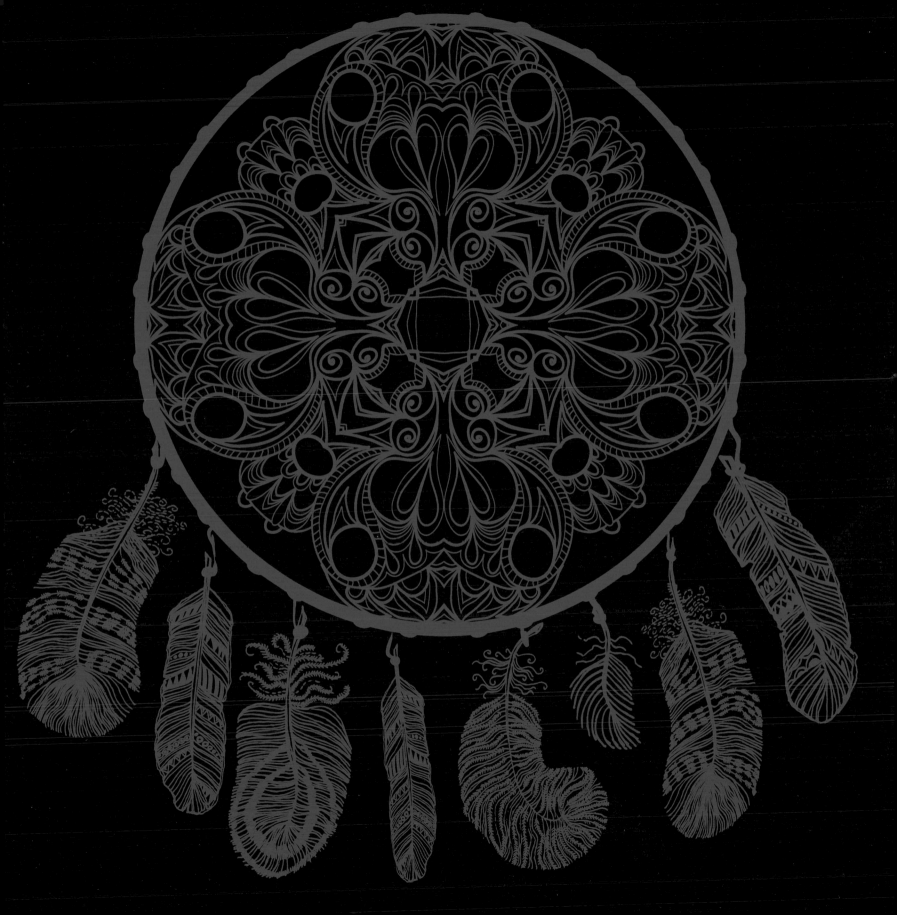

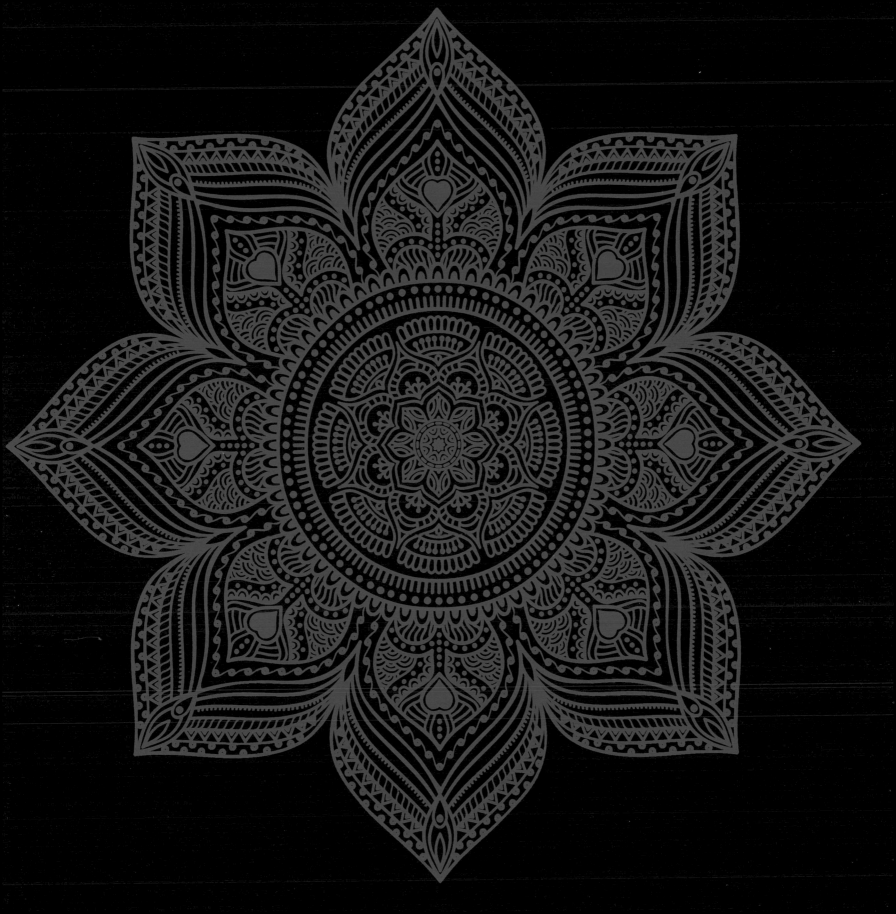

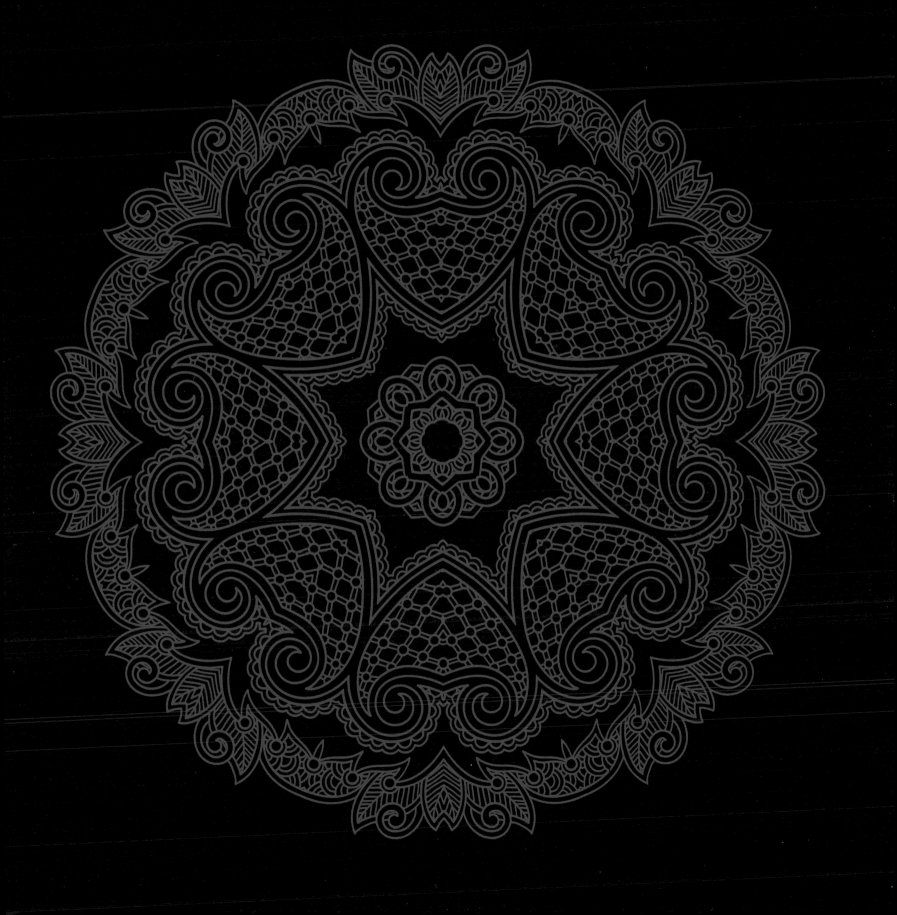

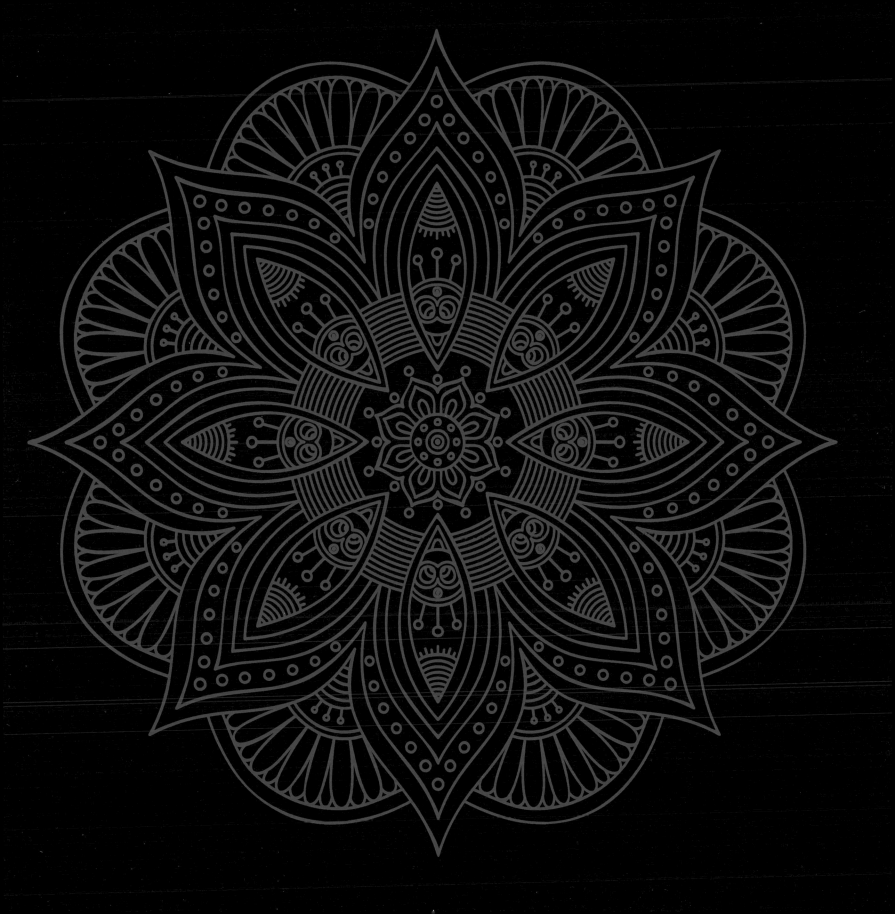

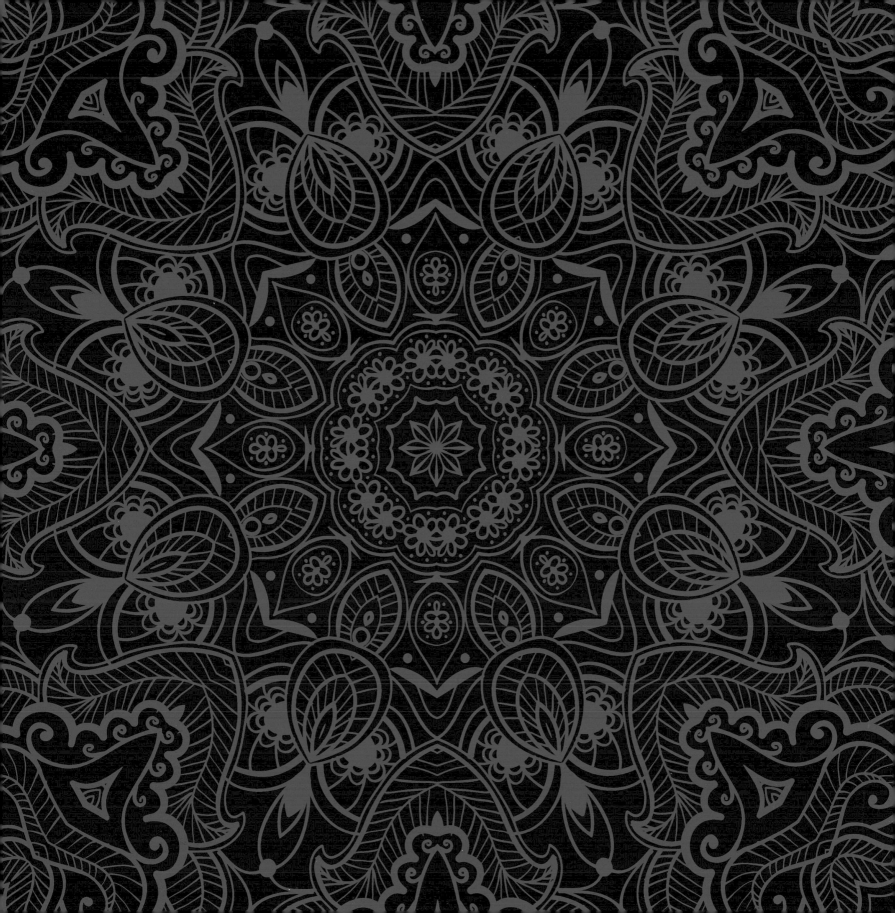

ART CREDITS

Interior: In order from first page to last (excluding pages with text only):

New York

An Imprint of Sterling Publishing Co., Inc.
1166 Avenue of the Americas
New York, NY 10036

ISBN 978-1-4547-1017-2

Distributed in Canada by Sterling Publishing Co., Inc.
c/o Canadian Manda Group, 664 Annette Street
Toronto, Ontario M6S 2C8, Canada
Distributed in the United Kingdom by GMC Distribution Services
Castle Place, 166 High Street, Lewes, East Sussex BN7 1XU, England
Distributed in Australia by NewSouth Books
45 Beach Street, Coogee NSW 2034, Australia

For information about custom editions, special sales,
and premium and corporate purchases, please contact
Sterling Special Sales at 800-805-5489 or
specialsales@sterlingpublishing.com.

Manufactured in China

6 8 10 9 7

sterlingpublishing.com
larkcrafts.com